# *WAITING*

ALAN GOLDING
www.alangoldingphotography.com

AuthorHouse™ UK Ltd.
500 Avebury Boulevard
Central Milton Keynes, MK9 2BE
www.authorhouse.co.uk
Phone: 08001974150

First published by AuthorHouse     7/13/2010

ISBN: 978-1-4520-2929-0 (sc)

This book is printed on acid-free paper.

authorHOUSE®

# FOREWORD

THOUGH HIS LANGUAGE speaks to all people, through his imagery the author addresses us individually. The familiar phraseology and fluid expression of common sentiments lends the words of 'Waiting' their universal appeal. Our ability to easily understand their meaning unites us in our commonality and we might glide over them unaffected were it not for the intuitive interjections of the author's provocative photography. The suggestive quality of these pictures and their indirect relationship with the text elicits a necessarily unique and original response from the reader who stops to ponder them.

Images are the language of our subconscious, wherein dwell our intangible desires, our passions, welling up from the mist of our imagination and taking form. We traverse this landscape when we sleep and it veils our subjective perception of the world in our waking hours. And its ours alone; no one can truly know if they see things the way we do. Therefore our response to an image is a private and a personal thing. Yet for every emotion we've ever felt, every epiphany we've ever had, we can find a phrase, a cliché; a familiar saying rendered meaningless through repetition, that describes just what we are going through. This serves to remind us that whatever it is, it is nothing new, we do not stand alone. We are connected with countless others who have shared, or are sharing that experience, even as we have it.

The words in 'Waiting' are an image in themselves; a picture of the platitudes we use to express our reality and they can remove our need to react emotionally to it as we travel. To protect ourselves from feeling too deeply all that we go through may enable us to cope at a material level, may enable us to be happy to an extent in our daily lives; to settle for what we have. But it is to live without dreams, without passion, without desire and every so often something will happen in spite of us, which penetrates our armour and we find ourselves re-awakened to an old truth – an old adage takes on new meaning as we reconsider it with a fresh understanding, in light of our own experiences.

To pursue our dreams we have to listen for those moments and allow them the emotions they inspire, allow the emotion to awaken passion, allow passion to give form to our desires and let our desires ride out in our minds while we carry on with the life we have constructed, or had constructed around us, but open – always open to those illuminations that will lead us closer to what we seek.

If we believe in our dreams our imagination makes them real and even if we cant see the rent in the netting we're caught in, it doesn't mean it isn't there.

Those who restrain desire, do so because theirs is weak enough to be restrain'd; and the restrainer of reason usurps its place and governs the unwilling. And being restrain'd it by degrees becomes passive til it is only the shadow of desire.

'The Marriage of Heaven and Hell', William Blake.

Whatever the mind can conceive and believe, it can achieve.

'The Antichrist', Lars Von Treyer.

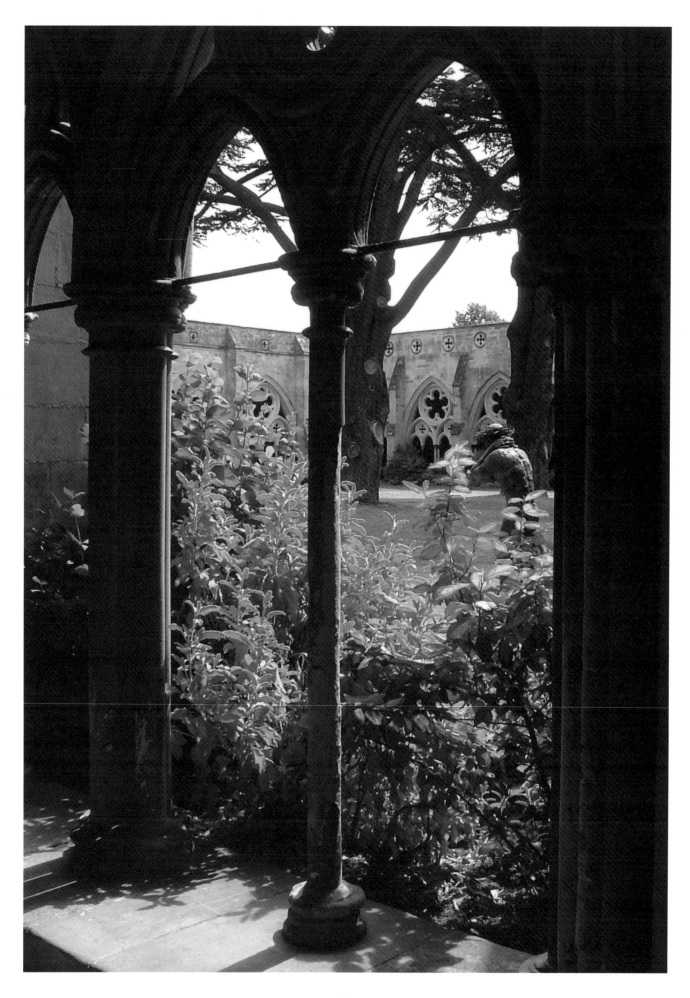

She lingers, here in my thoughts.
The desired, the sometimes craved, often times pondered; the charming
beguiling illusive. And during some of my darker moments; the fleeting yet
resiliently recurrent occasions of despair, of pained longing and anxious
need, the one who is perhaps an impossible dream.

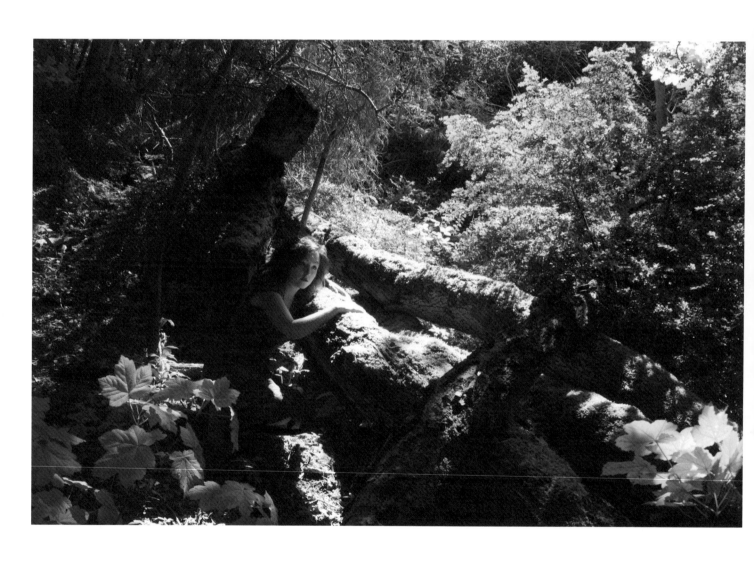

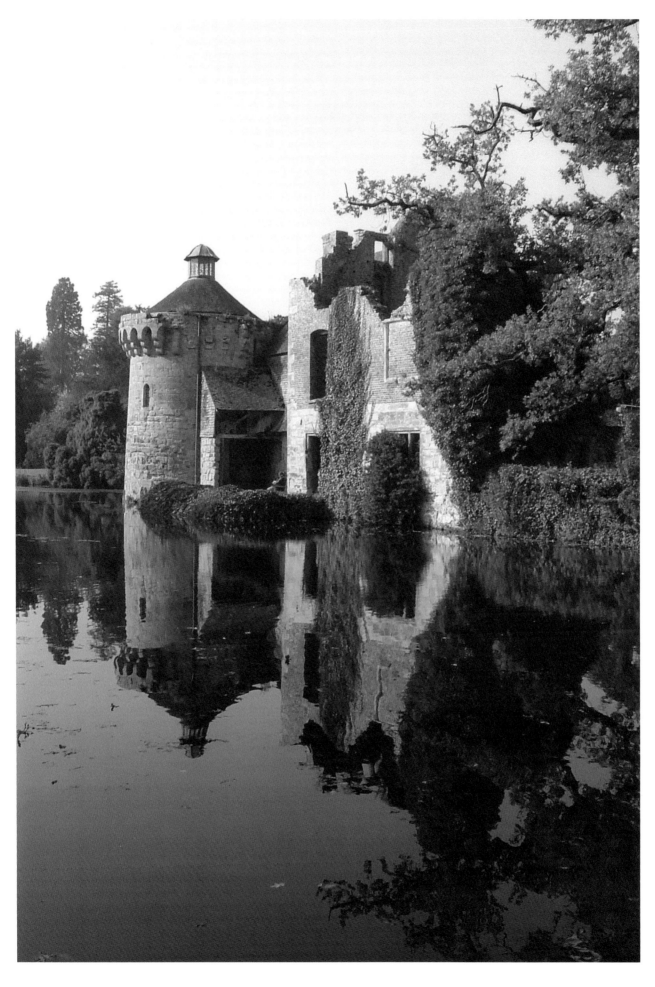

There have been journeys and adventures, seized opportunities and ignored possibilities, scenarios lived and spoiled, ventures planned and realised. There has been rejection and rejecting, signals missed, others seized. And in their own glorious realms, there have been grand tales and an almost lifetime. Each of them a move of the sculptors hand carving me into what I am; delivering me to this place in which I pen these words.

Here now, I drift occasionally to reflect on paths that have crossed and some that may cross again. For perhaps what is past is not necessarily lost. Some doors ajar, some closed and locked, never to be revisited. Others no longer there, never to be searched for, never to be found again.

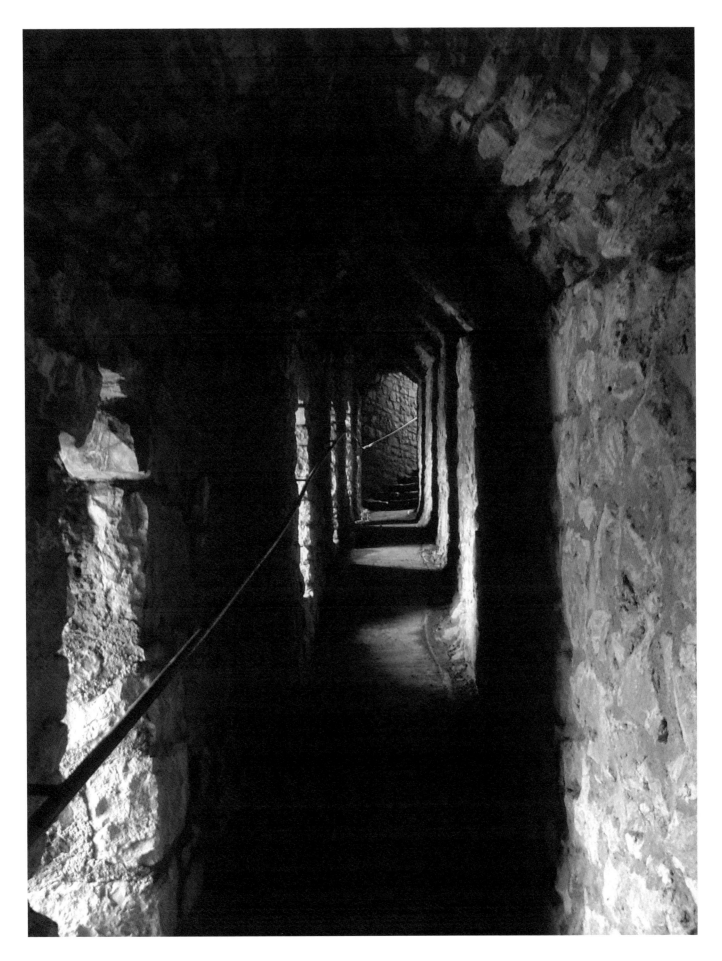

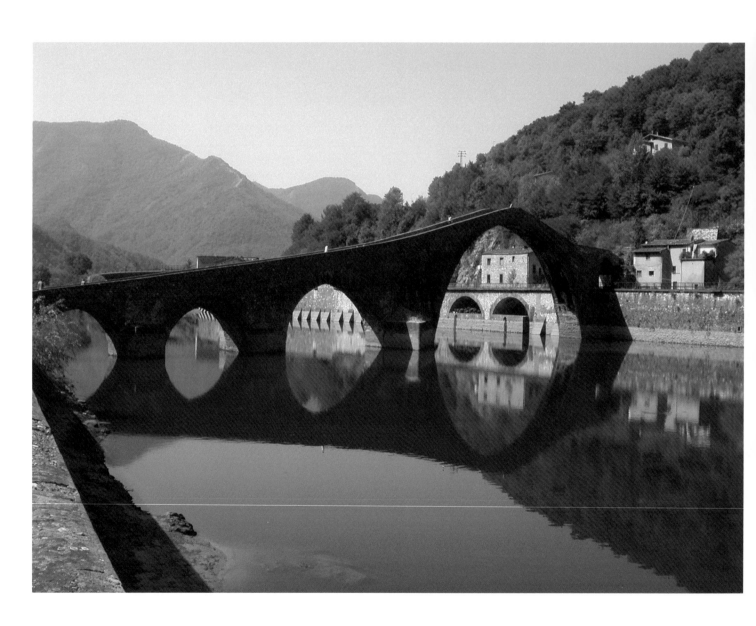

Acquaintances and lovers, crossed paths and shared chapters have all given to me many wonderful treasures, and I have taken what I can from these. Sometimes a little later and perhaps too many times retrospectively. But we have to find our truths in ourselves, of course.

My truths had to be found by my finding them. And perhaps now, with some, I have. The old adage`s so often heard themselves are truths needing to be learnt, rather than simply listened to and followed. For how can our lives be true when we are lying to ourselves? A denial that burdens and harms, perpetuates a self deceit of such weight that the shoulders are eternally heavy.

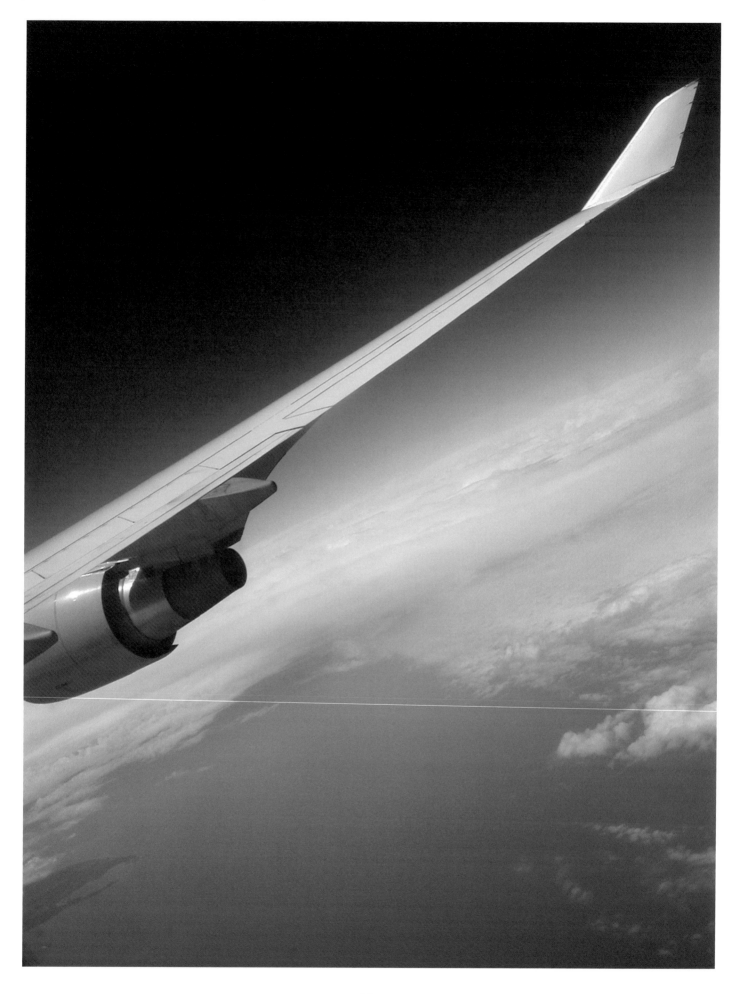

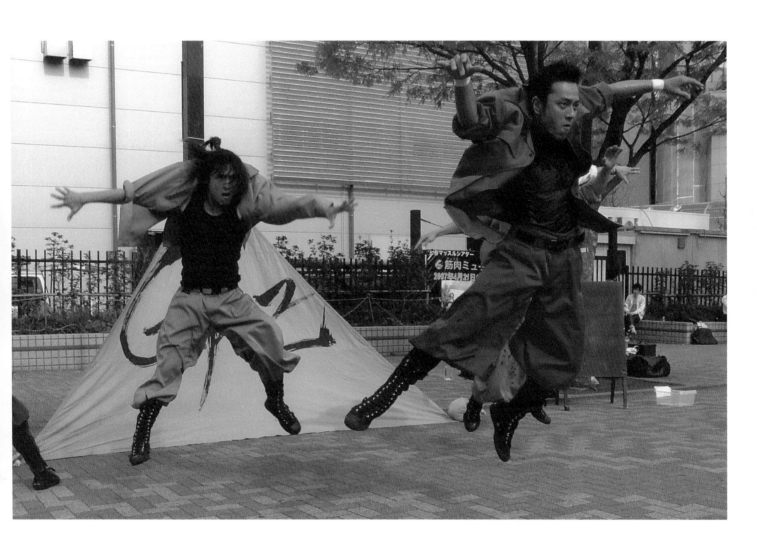

And now from that drifting I slip into pondering. For I am ever thoughtful.

At times I have studied and read, conversed and debated, oftentimes aiming to find something... something...

Broodily and unapproachably I meditate upon myself and my life. For we must not always seek in others the answer to all the questions when so much is within us, and so strong is our often neglected ability to instinctively know what is right.

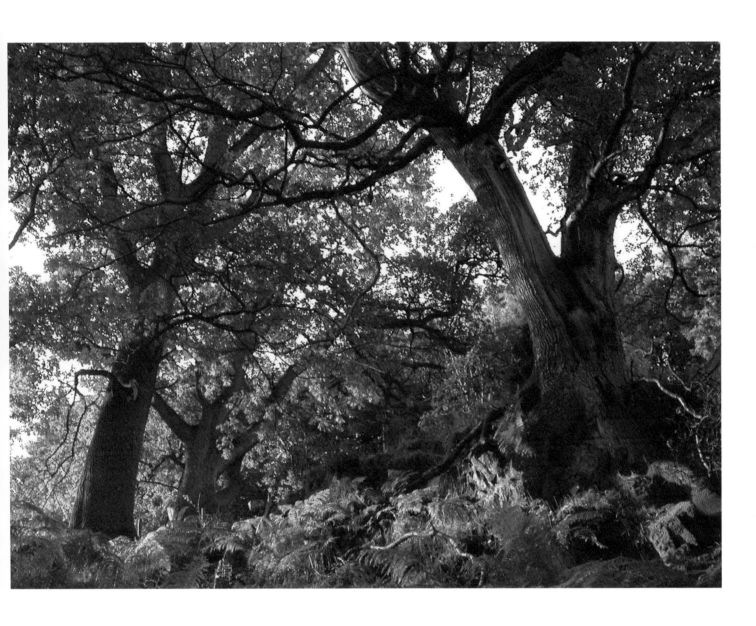

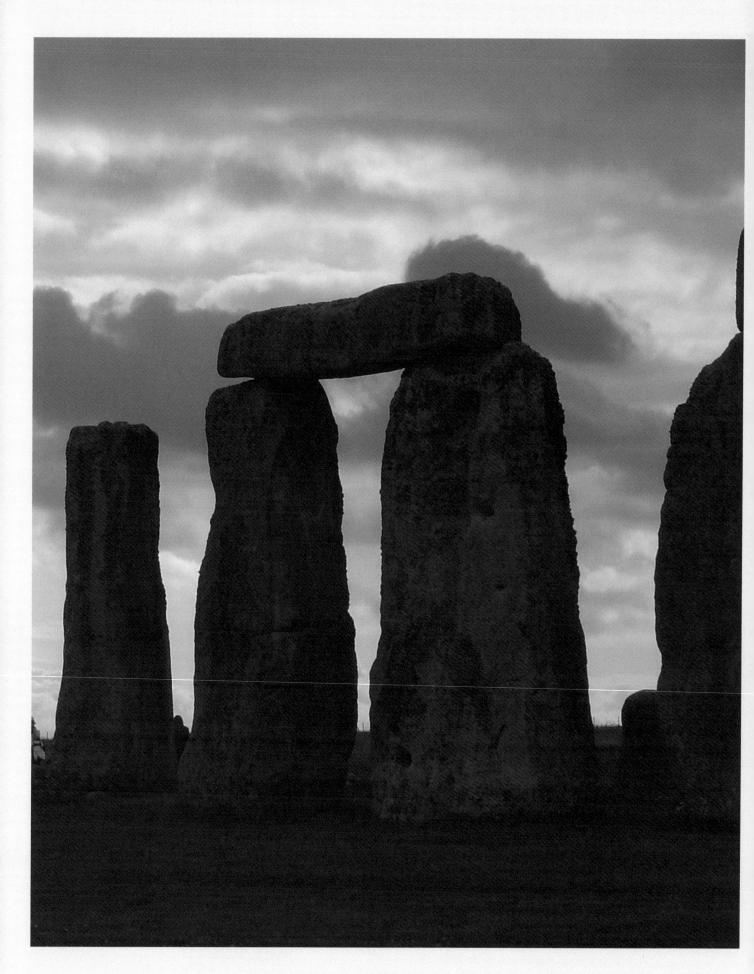

Resiliently hopeful, perhaps of a classically romantic idyll my desires rise and fall, as do these tide and wind driven waters that sometimes caress, other times crash upon this stony beach.

As each day comes and goes, along this path I tread, this walk through life I take, the desires and the thoughts, they come in varied fashion. Sometimes I see every single smile as a positive. Every glance as an opportunity to want. And on other days I am so tired that the thoughts are almost absent.. Almost?..

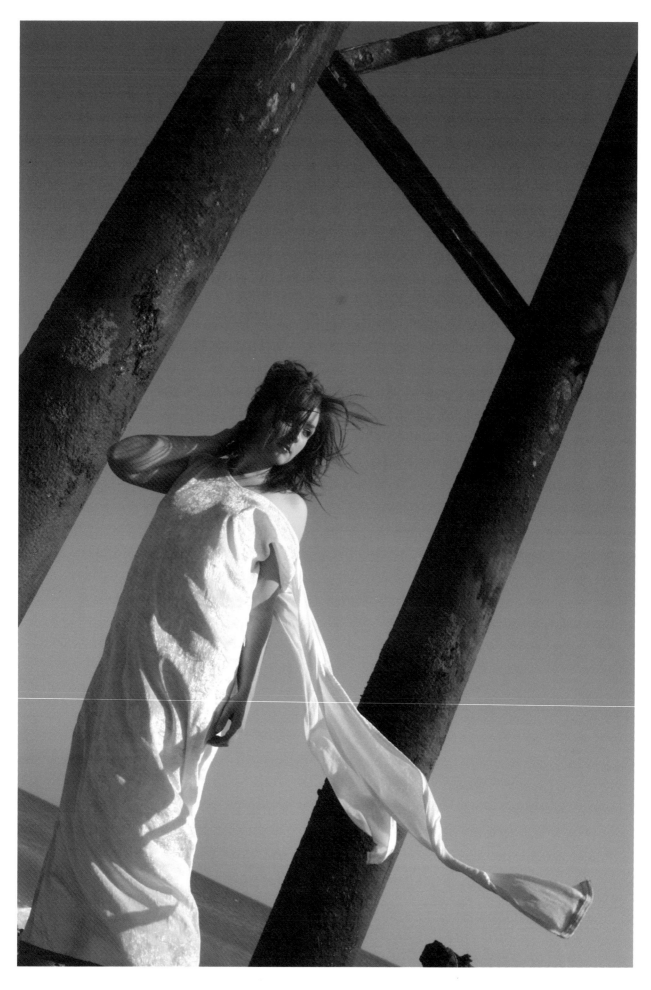

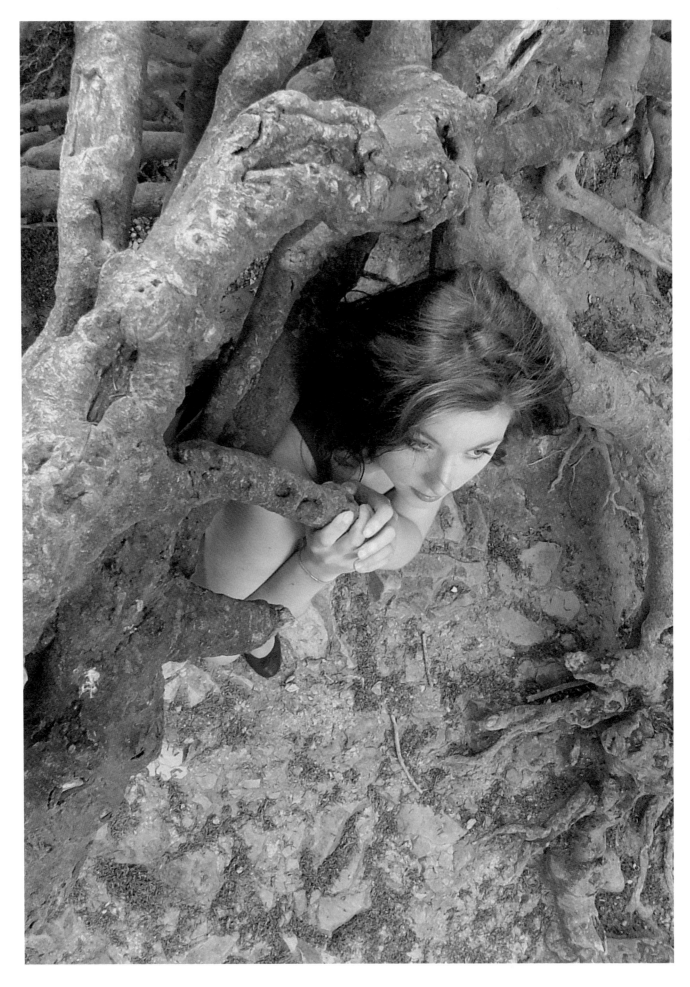

And yet through the desperate times my hope remains, for she must be somewhere..? She must surely exist, or am I living in some dream where the perceived possibilities and the occasionally false promises and raised expectations of hopeful lovers have led me to believe that I can be the whole me that I have long wanted, yet still have someone, She, in a place where compromise is hardly present at all, and battle and loneliness are simply not a part of what we are.

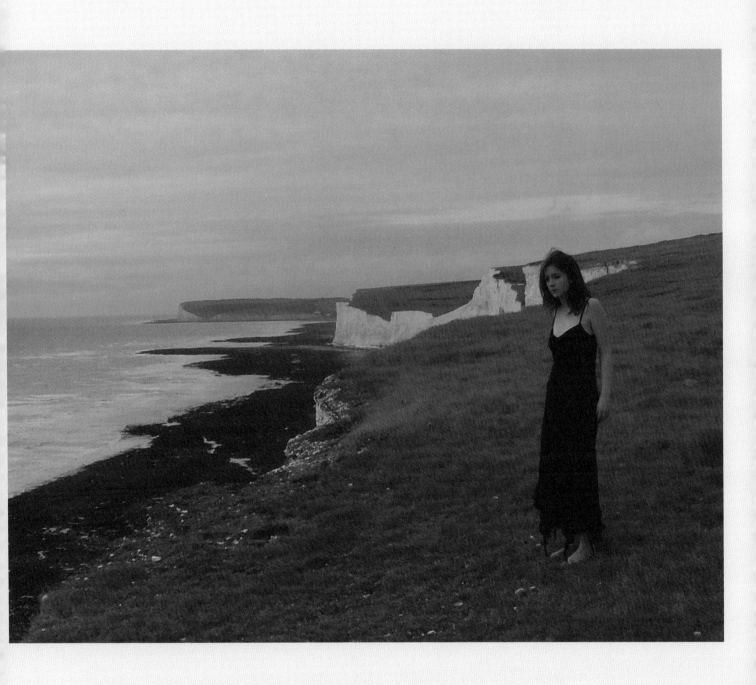

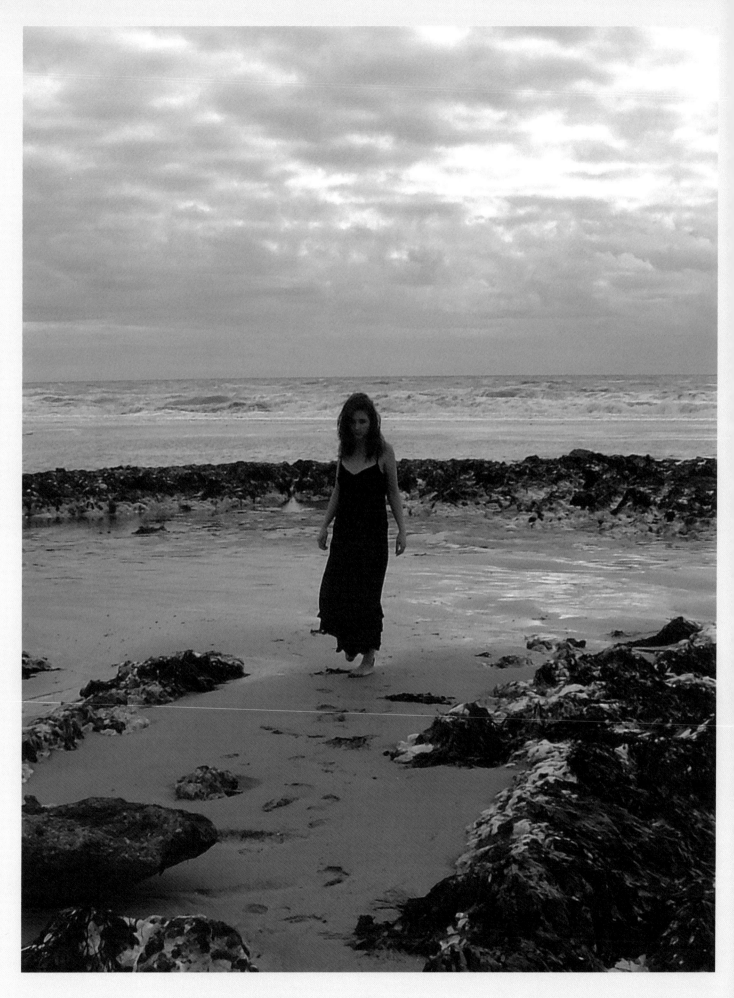

As I step into the day, a refreshing autumnal breeze offers its cool breath after the months of warm frenetic activity. I head immediately down to the sea, and walk across the pebble beach to gaze out at the midmorning colours. How many times have I stood and marvelled at the grandeur of a landscape, and in so many climates. And this view that has called me and held me every day, has changed the direction of that gaze. From landmass to expanse of sea, to the water that I once so feared.

I stand and watch, calm and shallow of breath.

"You must stop pondering so much, it cant be good for you" she had said and I laughed.

I start to walk further. Keeping close to the water.

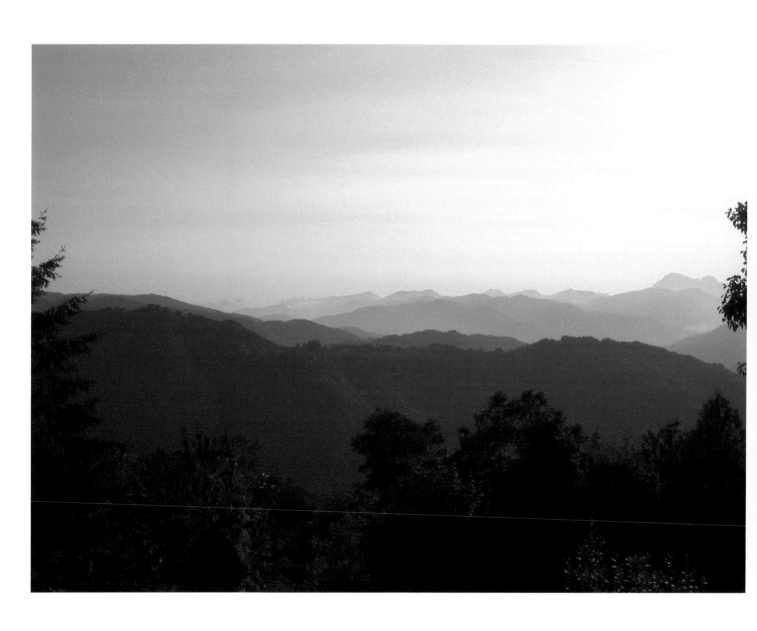

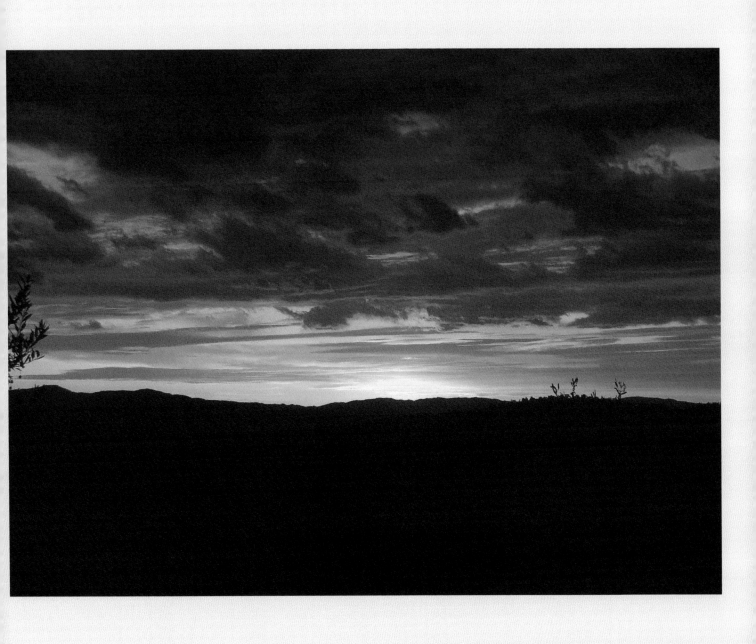

It is late afternoon and I have walked a considerable distance.

The incandescent orange glow of the sunset is fading fast beyond the rusting pier, the derelict structure once grand and alive.. slumbering now towards its melancholic end, awaiting its fate at the hands of men, or of time and the relentless pounding of the wind propelled waves.

It is time for me to leave, and with no sun rays to warm me, the cool October evening is settling in, an Indian summer it may well be, but chill it remains.

I head for home. Passing the last few walkers along the promenade, my thoughts are erratic, interrupted only briefly by the sight of a silhouetted figure on their craft, weaving their way through the eddying currents at the piers footings. Another someone alone and heading homewards perhaps.

I am accompanied only by the myriad of starlings dancing away to the final rays of light, beckoning attention from the eyes of the last of us observers to relish their autumnal sunset chorus.

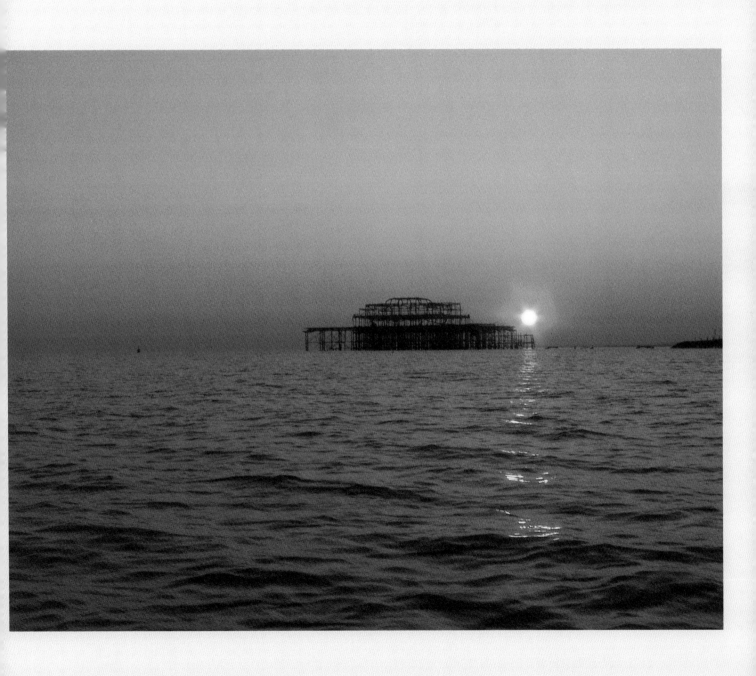

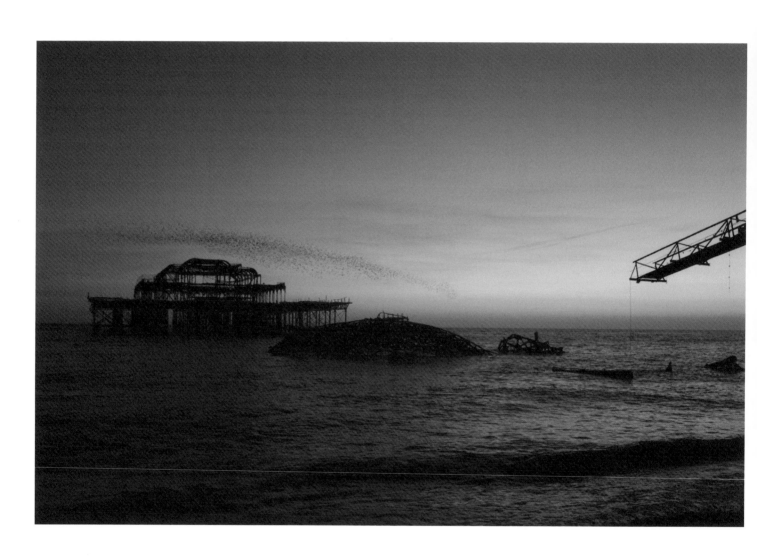

Is she waiting, pondering similar thoughts? Is she out there in this world, close, or distant, thinking along intrinsically identical lines, hoping that I will walk into her world and say hello. Is she waiting, as I do, longing living chapters as they present themselves and yet always knowing that there is someone who must surely present themselves. Or has the time passed and a more jaded and mournful loss set in. Of what was wanted but never found.

An acceptance of almost tolerating in the absence of purity.

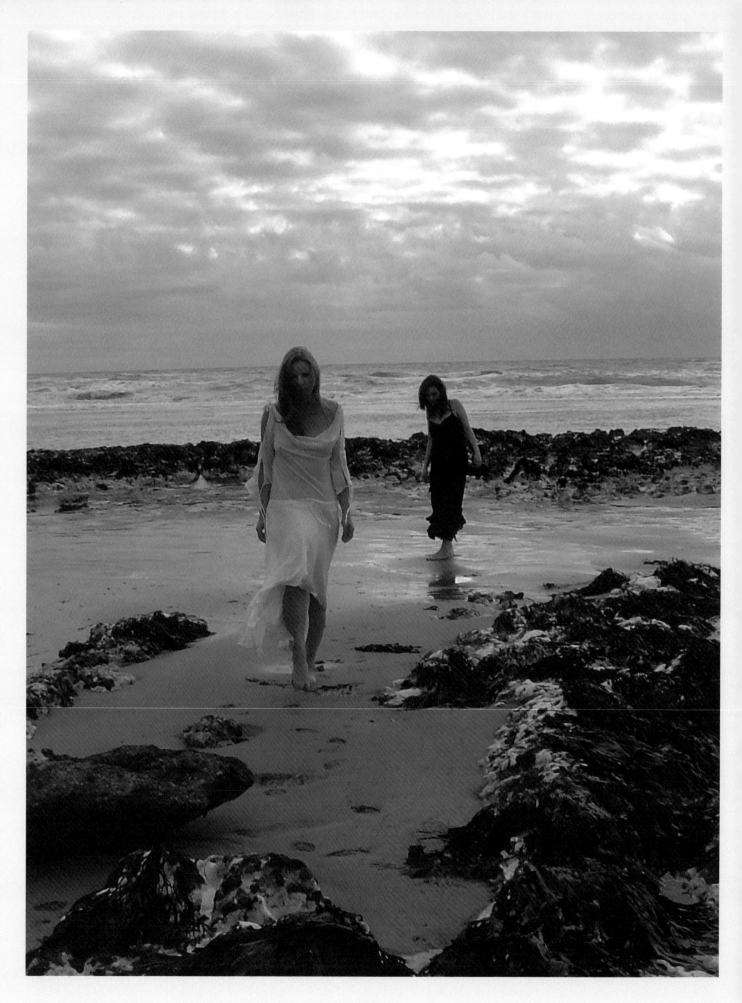

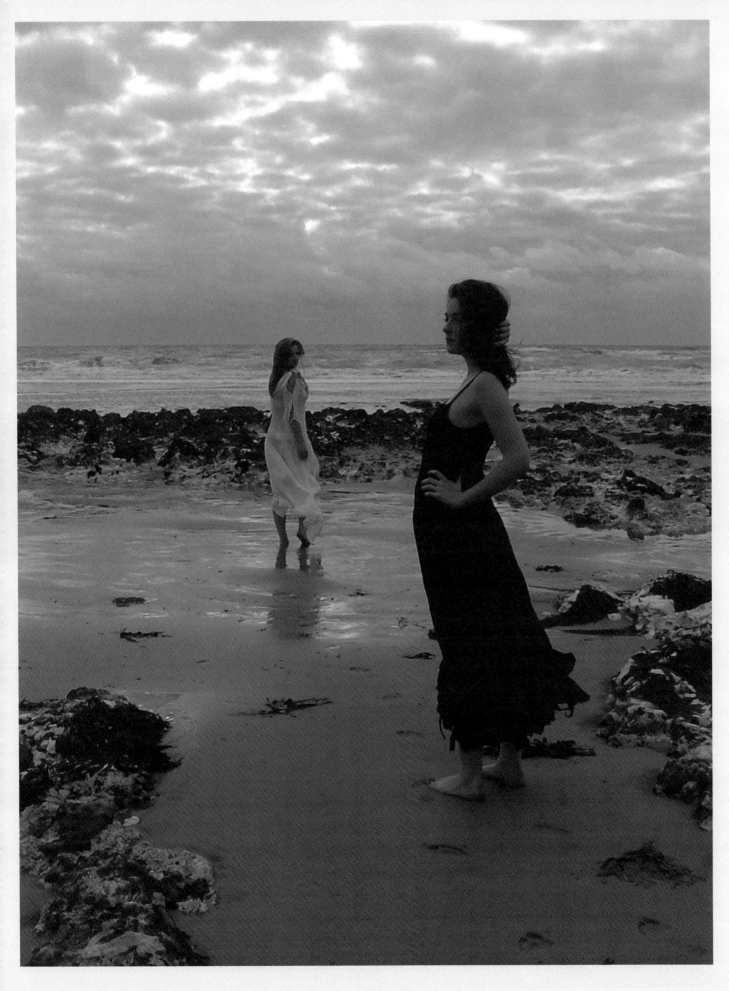

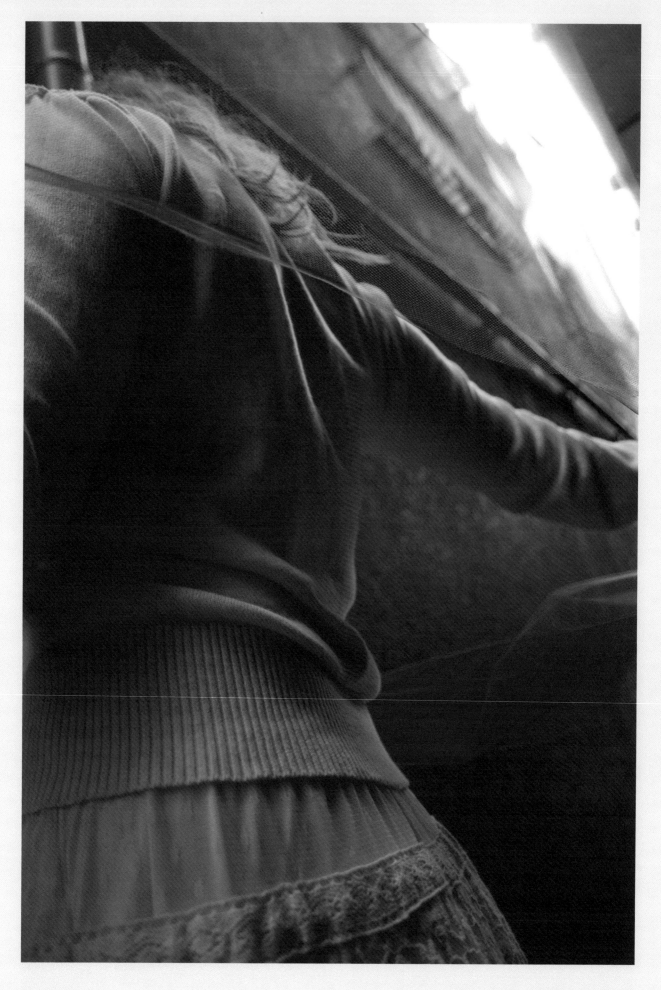

I am cold now, and gladly almost home. Soon to find what distraction I can in this, my harbinger of what was before and what is needed and now sought. For winter is casting its cloak to these lands, and today, as with this past week, the sun is lazily sprinkling its subdued light to these shortening days. And as the rains of yesterday have passed, there is a distinctly autumnal feel to the day, and with it a time to reflect and rest is upon me.

A day ends, and sleep beckons.....and i am creeping into morose........

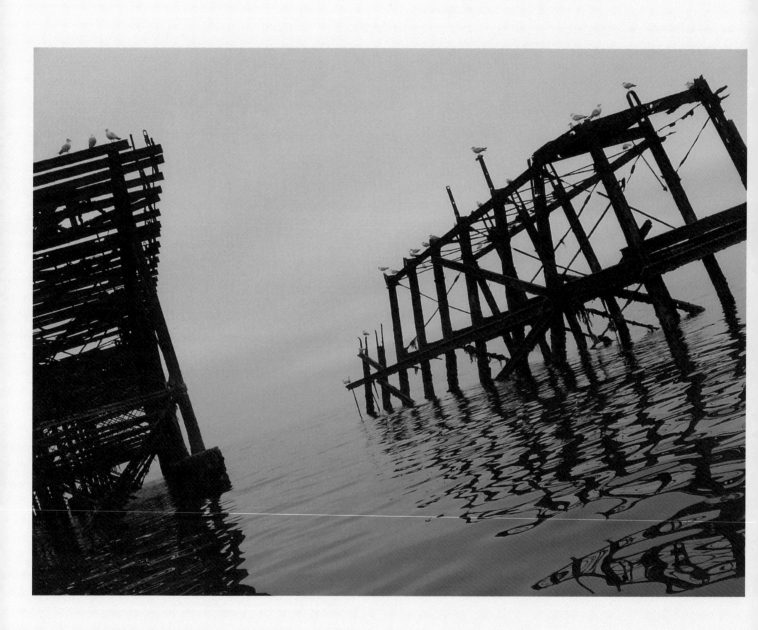

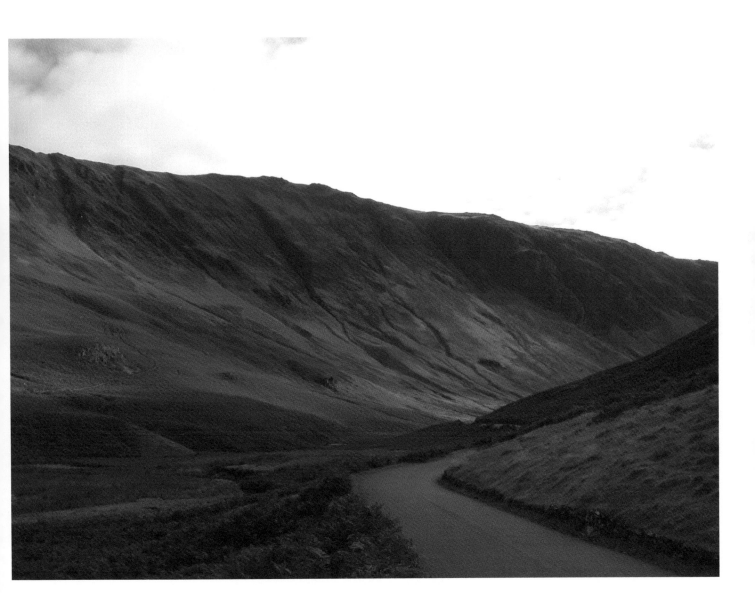

Falling, sinking, or am I clambering? How I find myself in the pit is

different each time. The force with which the change becomes apparent varies wildly and only sometimes can I sense it looming, and now, undetected, slight yet threatening, once more, it is here and calling me.

The arrival of winter has greased the rails, and here I am once again, down in the pit, my pit.

It is dark down here. Down…. Here. And yet there is comfort, for some brief time, an almost pained yet loving melancholy.

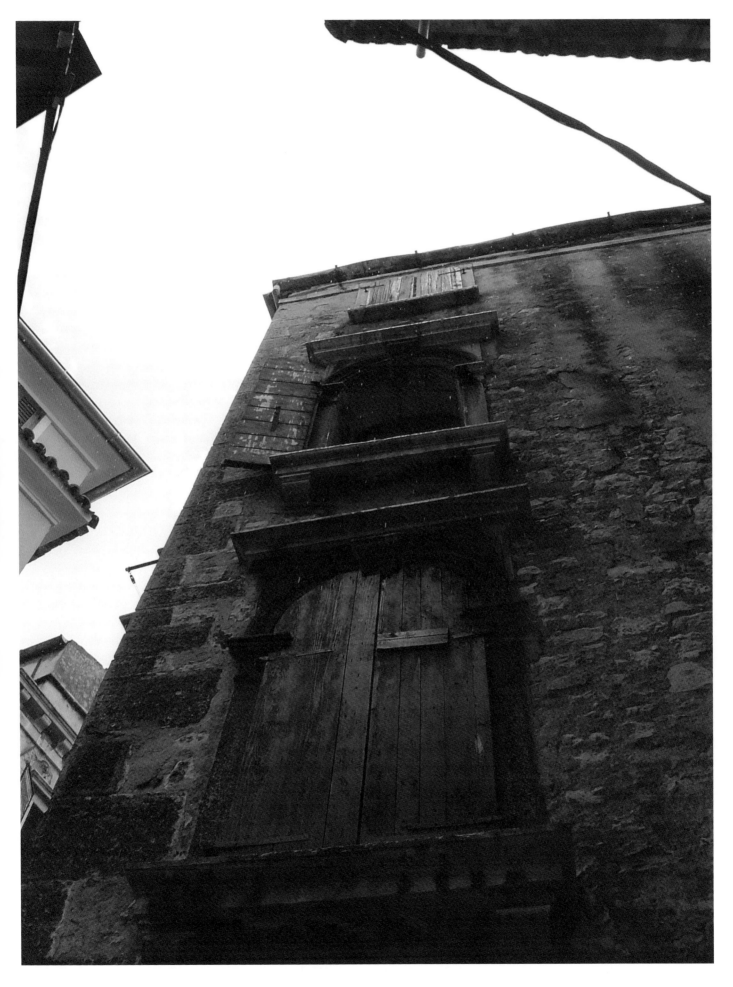

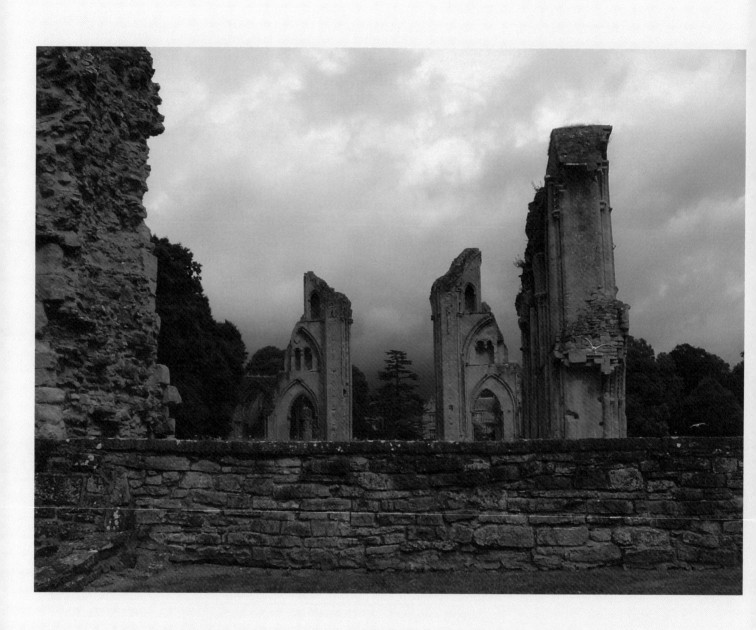

Come….. Closer….. Run…. reach, you must answer my beckoning, I want you here, in order that we can leave.

You and I.

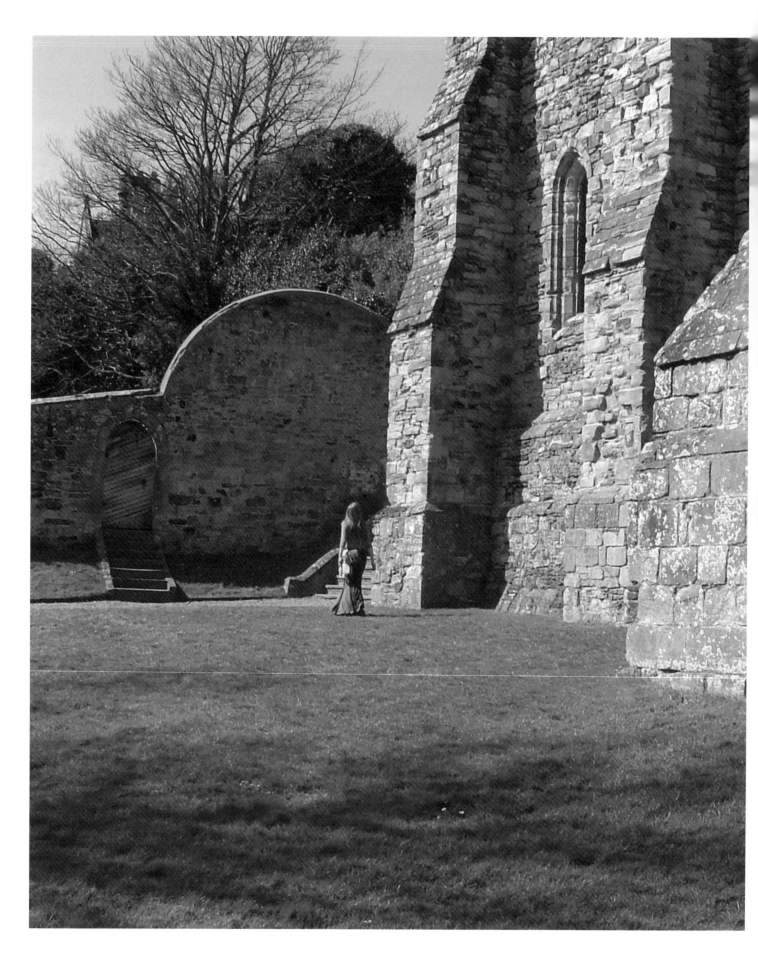

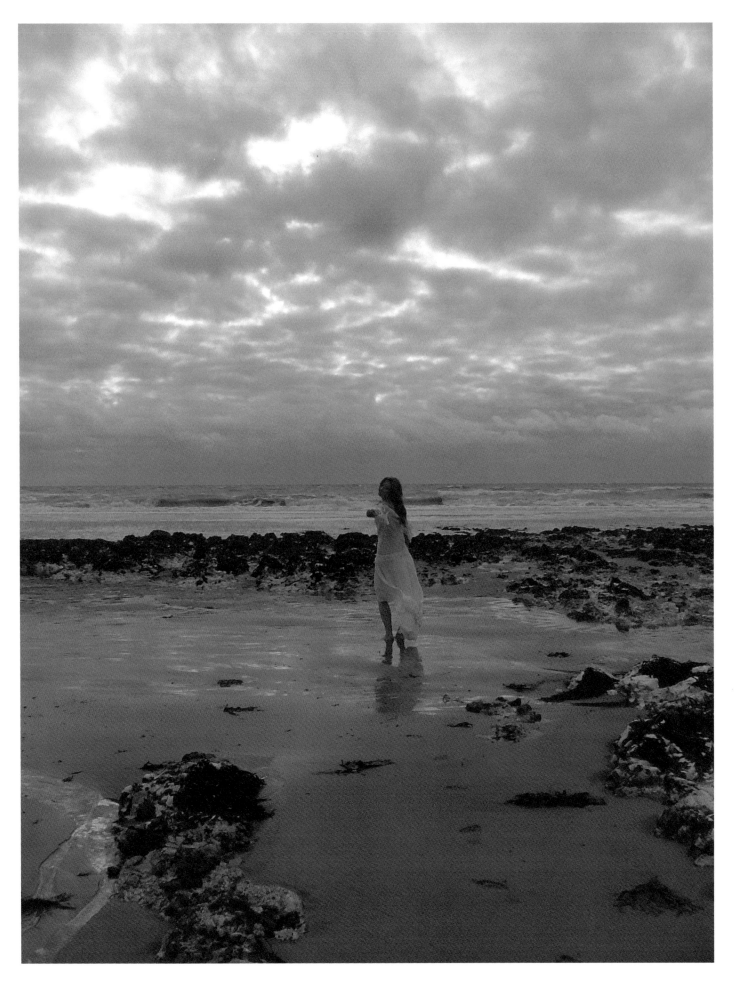

Stay away.

You are not welcome here in my place......... this, here, is for me alone............

As years have passed, it has changed, this place. Yet it is still the old familiar, crushing it remains, yet there is comfort to be found, as with the company of an old friend......It is almost as if knowing where I will be for these days makes it more tolerable somehow, almost welcoming. Tolerable, how amusing. Can anyone understand, can anyone see the lack of depth the word conveys as I write it down? For it is not tolerable. And I must not allow myself to dwell down here, I must not allow this time to draw out or become more than just a visit, for as seemingly safe and undisturbed a place as it is, It is a cold and crushing void, a dark, dark place and it brings doubt, the unfulfilled hopes and frustrated attempts of goals usually left out of thought. It harbours the negatives, and it unerringly tries to chip away at my confidence and my self belief.

It sits almost the ever present dark sail of a foreign vessel, poised for the marauding attack. Sometimes only a speck on the shimmering horizon, now the view obliterating full of sail hulk that lumbers towards me, and soon it seems, I am to fall under its wash, caught and overwhelmed, knocked from my course, my stand dismissed and my footings wrenched, my very core cast as it will have me for awhile, until my struggle ends and I resignedly wait for my new course to present itself. I want to find something, I want not to be here, and yet I am torn for on occasion it is a craven place.....a haven. A dark hole that shrouds and yet disguises me from the day. A prison and yet a place of safety.........a sanctuary.

And with this lack of course, this shrouded haven, so much is lain to fate, left neglected or simply allowed to make its own way.

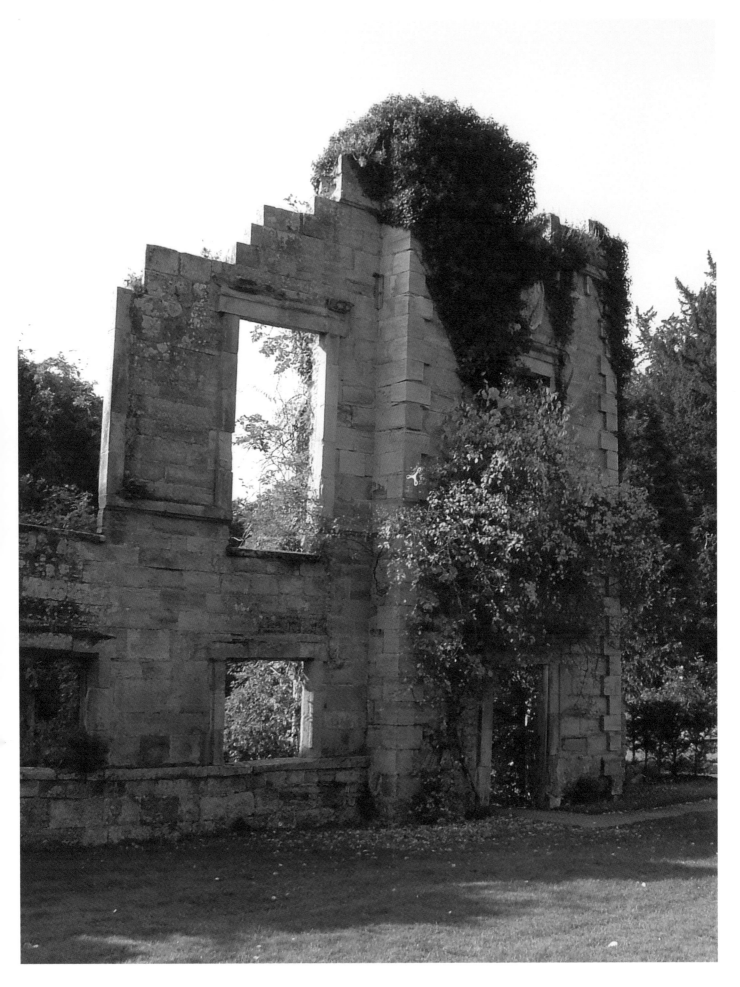

And I have caused this, this array of broken and scattered belongings. This collection of unwanted or no longer used paraphernalia. This scene of chaos. This random spread of objects and mementoes…….. This unordered mass that beckons to be placed, sorted…………….

And to her I have been he who led, and failed to recognise, or to find what I had wanted and then left her abandoned and maligned, forgotten almost and cut with a dismissive walk away.

From this chaos, perhaps, amidst the items swiped from their shelf, strewn, I long for a clarity. A different frame of mind, a positive and more powerful step.

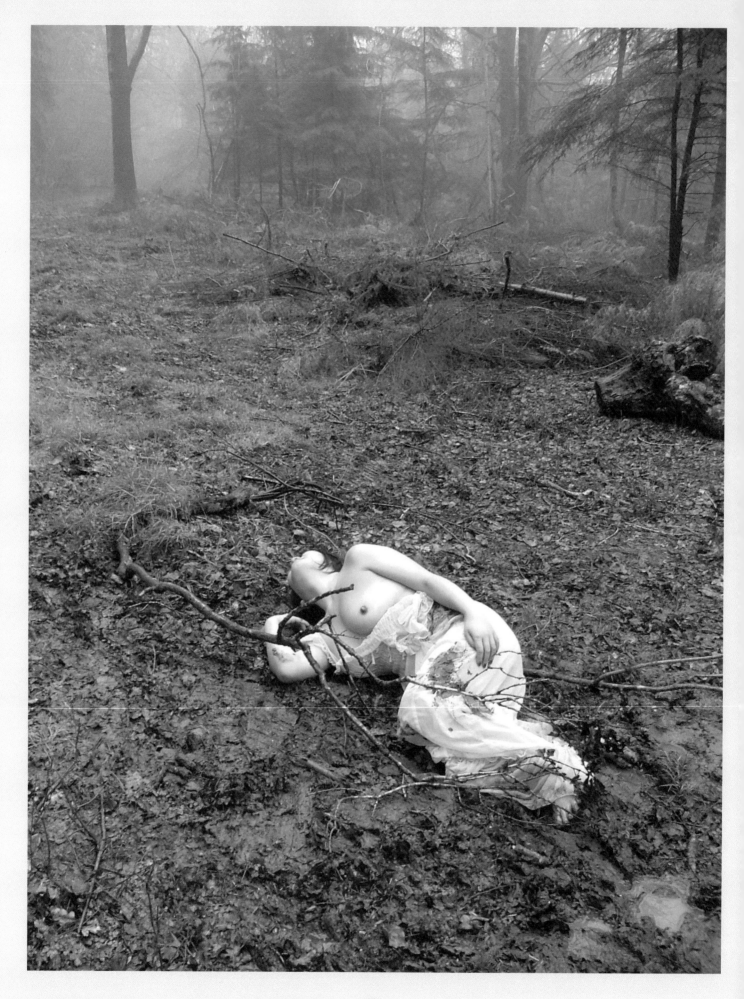

For almost rudderless I have become, and with a wanting not to be continuously adrift. I want to feel and I want to run.

And in a moment, just as the prayer I have made a thousand times almost rolls from my lips, Just as it seemed as if today was going to fail to be anything other than the drudge to which I am already consigned...........

She appeared!

A stranger in as much as I know nothing about her, a familiar face amongst the people on the train to work. The mundanity of the commute broken, my breath a gasp, the literal skipping beat.

A hesitation, a glance and in a moment the words came and brought a look and a smile.

A very pretty face, a woman with immediate desirous appeal............ and this is what it is like to be alive.

And for a day it is the thought that drives.

A carefree, desirous, steam train couldn't knock me over kind of day.......

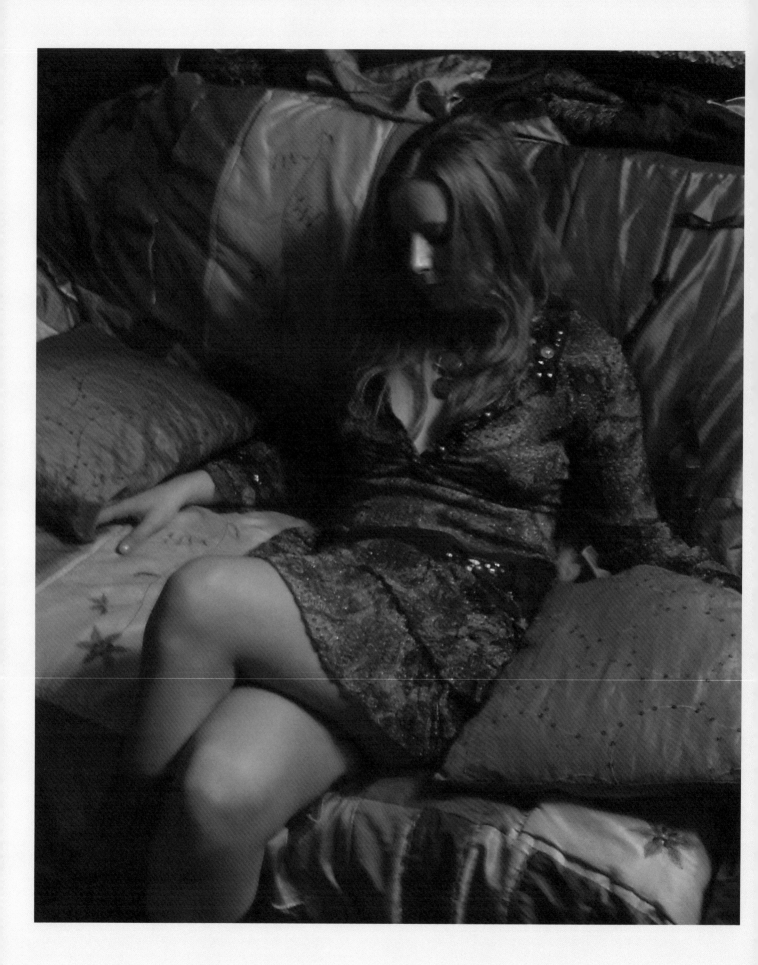

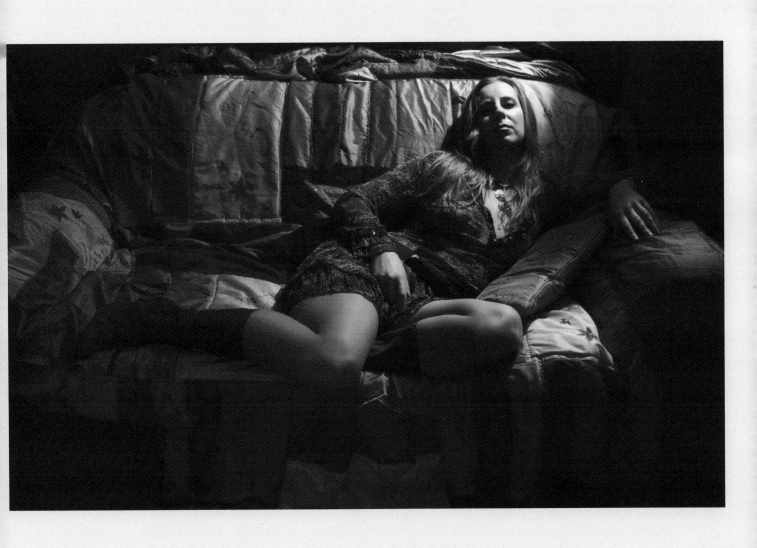

Frozen in this almost state of arrest by the glimmer in her eyes, I instantly forget all the occasions that I have witnessed a moment that is close to my desires, my dreams and my longed for. Brief glimpses occasionally yielding such a sparkle, lovers and acquaintances that have offered moments of wonder lust, enough to feed the desire and the hope, yet failing to anchor. Close, sometimes, so nearly.

Has it really been with such a frequency that I have felt this, seen this, at times almost embarrassingly. Confusing perhaps the momentary lust with something much more profound; convincing myself from yearning that a single gesture is a call to which I must answer.

A cold, misty morning. From the train the fields are bathed in a heavy snow-like frost. The trees black and shadowed in white with the nights ice, a biscuit tin winter's morning.

Yesterday cold and chilling, today in its apparent similarity, the temperature is completely inconsequential.

Will I see her face today?

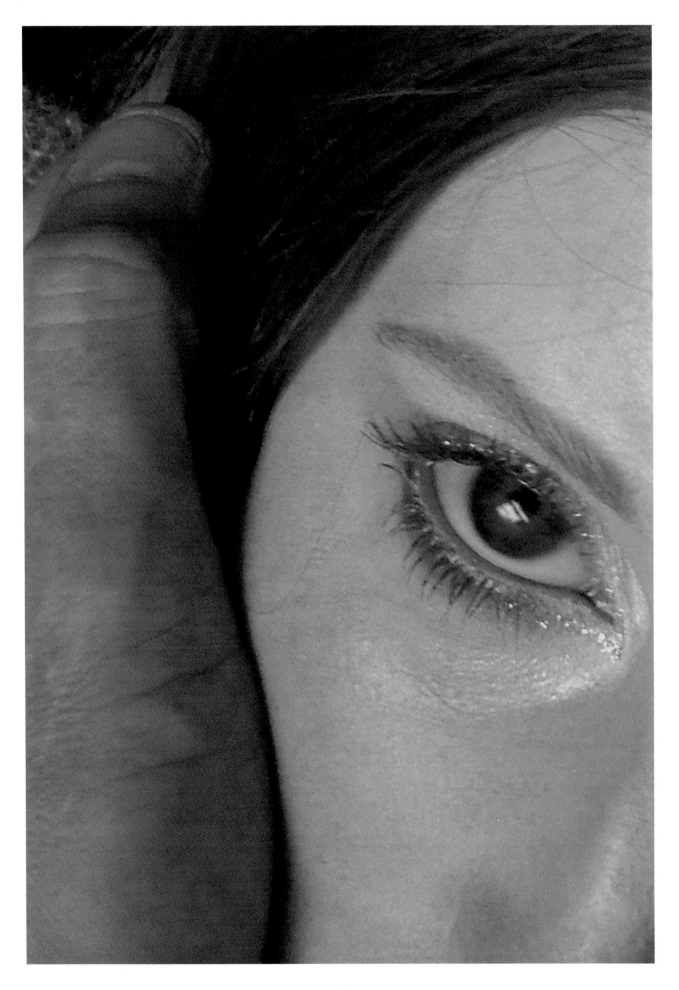

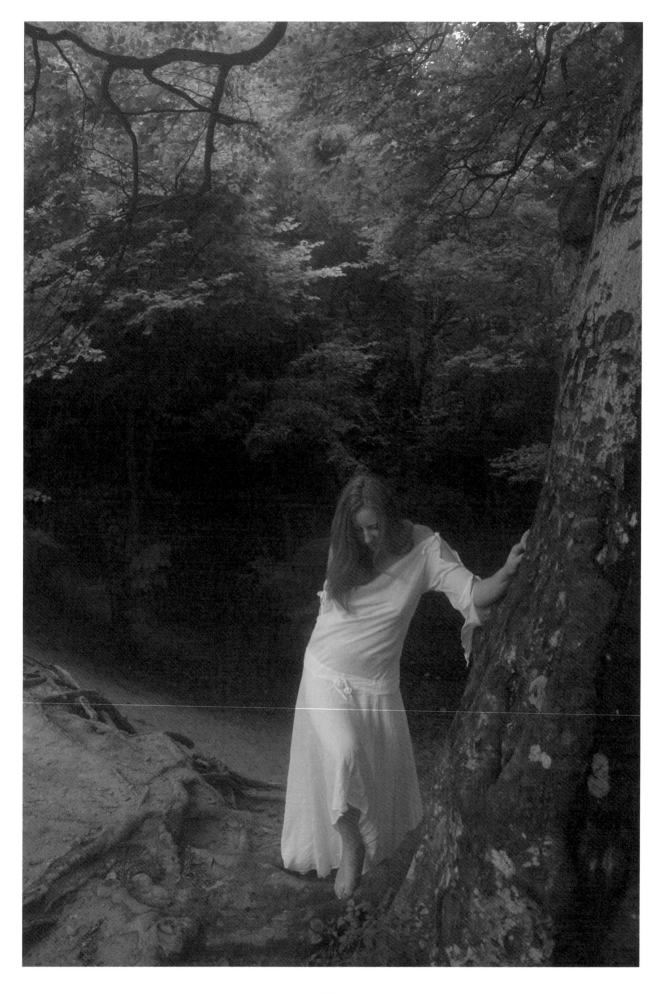

Those thoughts were weeks ago, I recollect, and the desire of that time, so often experienced in hopeful moods, has fallen away if it was ever there. For I am sure I walked past her once without even wanting to say hello.

And so, a momentary burst of possibility fades as it has on so many occasions, and I am back here, waiting. Pondering what it is to wait, thoughtful of the words I had spoken in conversation; that all around us there are people who are waiting.

Perhaps in a relationship of some kind, perhaps alone, many occupying their time in an 'almost, till the real thing comes along' frame of mind. But waiting they are. And in these photographs I was looking to capture waiting. The fact that all over the world, there are people living their lives, passing their time, in or out of relationships, seeking pleasures, pains or loving, not even thinking of meeting someone and yet still they are waiting.

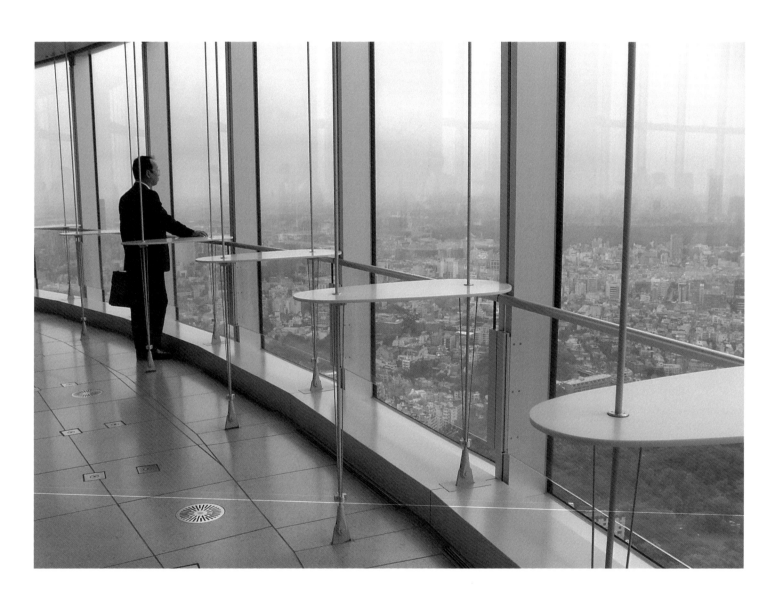

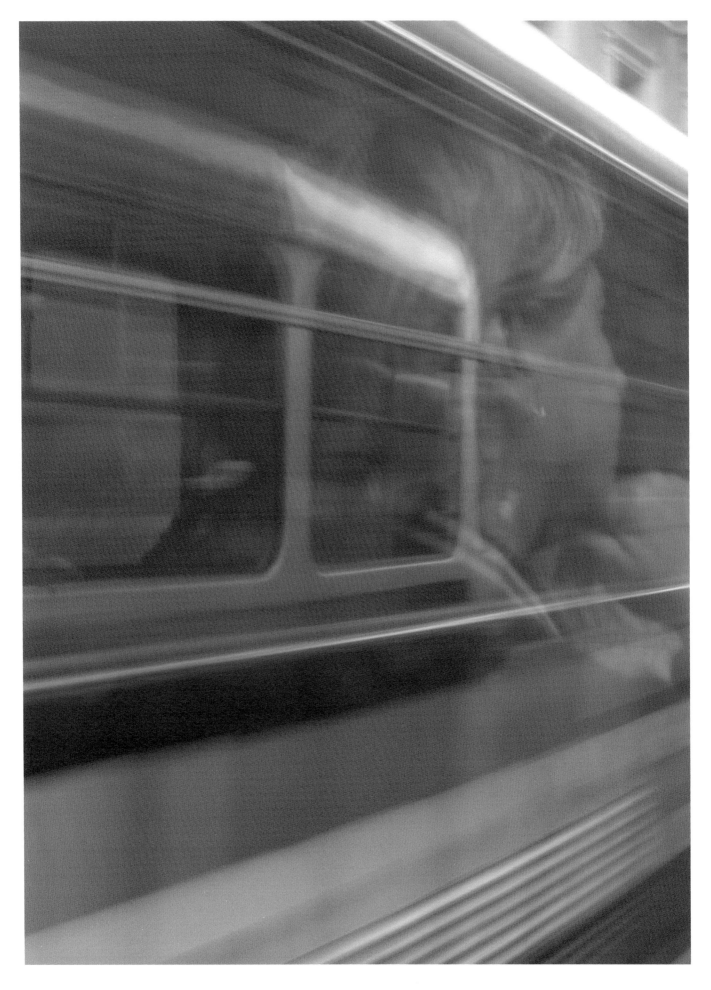

I feel so insignificant.

One person amidst the crowd .

I want to shout…… or pass unnoticed.

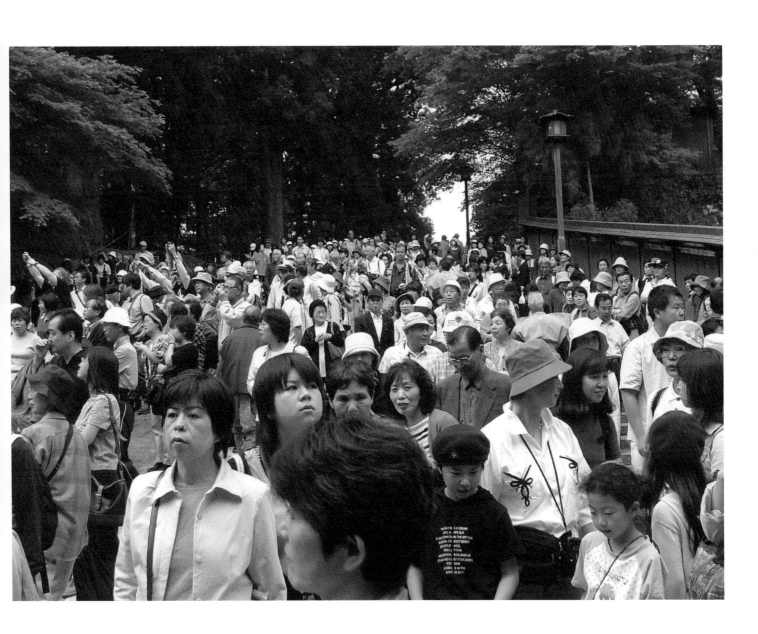

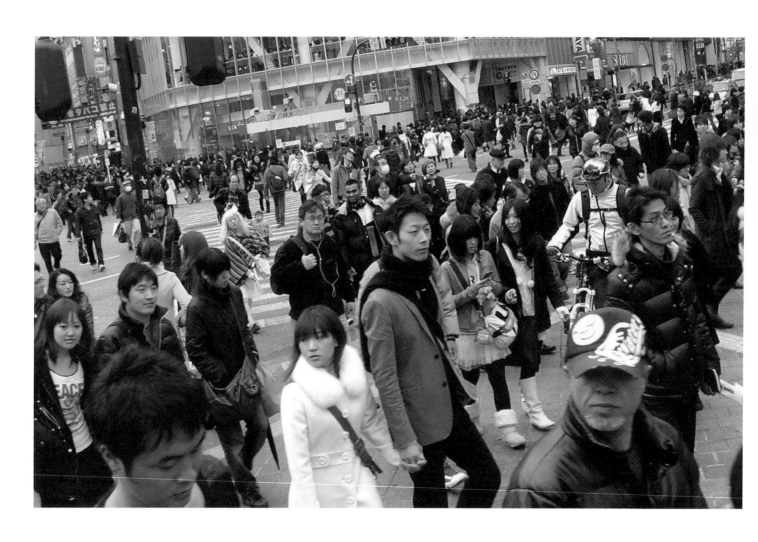

I feel as a giant would amongst lesser beings.........

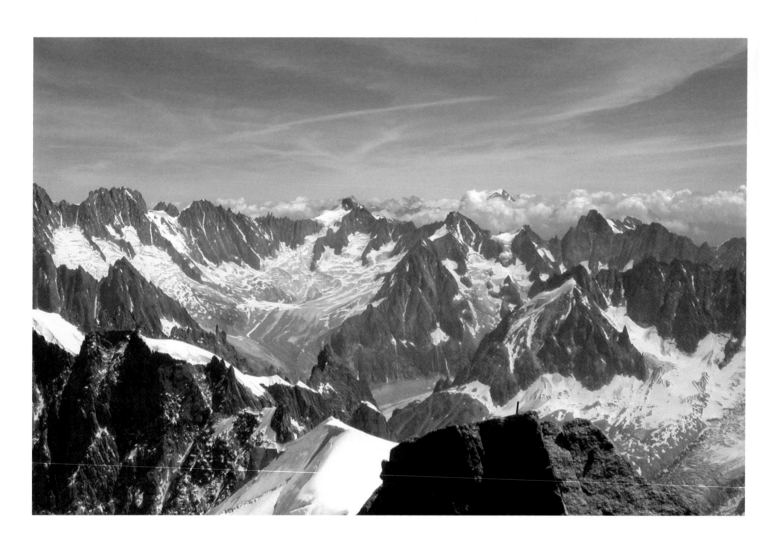

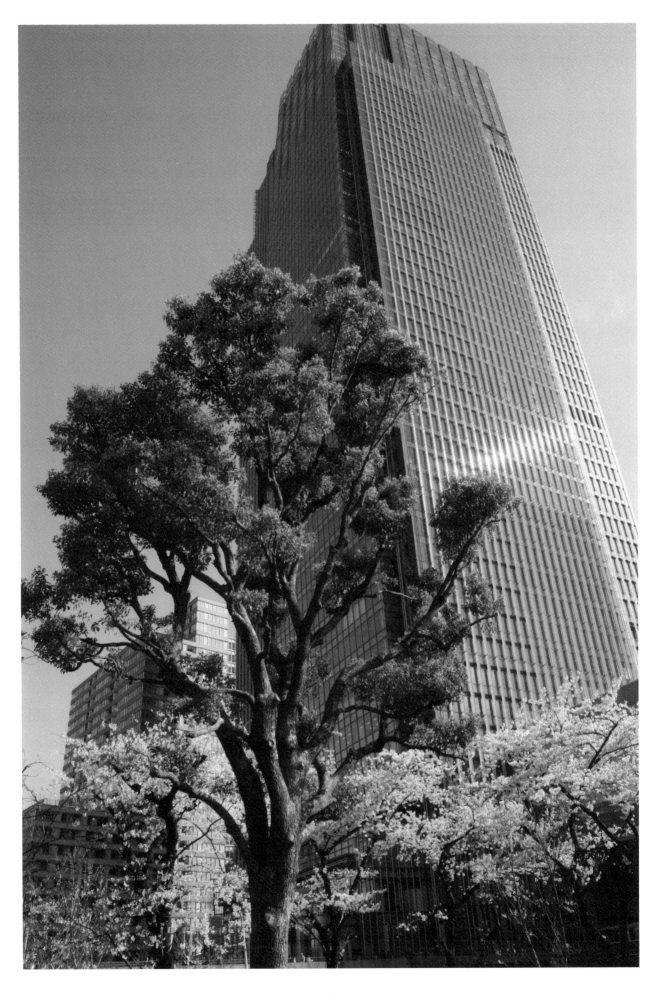

Paths lay before me, endlessly, directions to choose.

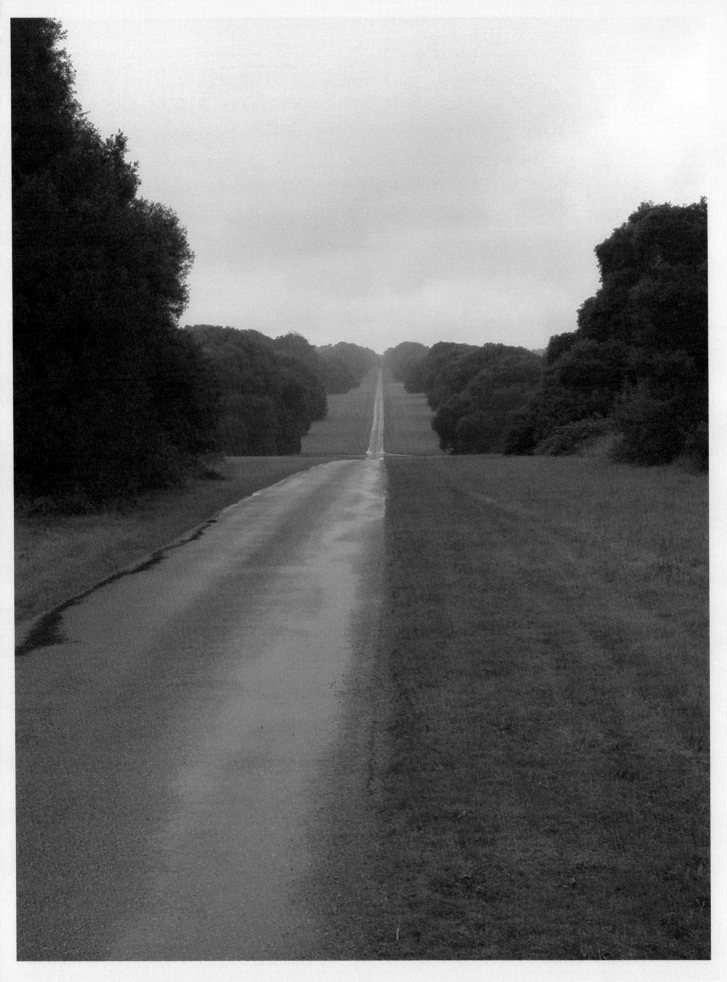

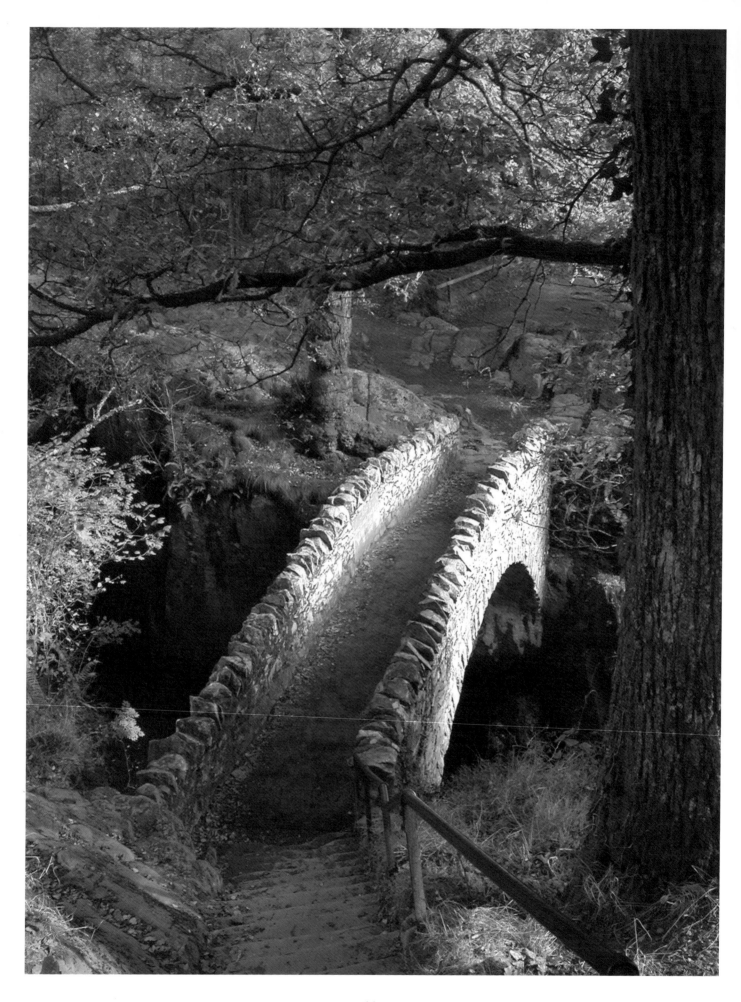

Here in my tower.........

I take rest and refreshment at the grand oak table......

I am a romantic and see the dreams often; the flickering flames of a wood fire, the goblet of wine, the candles and the finely attired woman in a most magnificent dress.....adorned..... I blink and return to a familiar view.

One day perhaps, something close. Fragments of the dream found sprinkled and grasped for. And now, here during these weeks, elements so close to what is desired yet tantalizingly lacking the dream or the timing. I am taking the steps up to the brink and then seeing them leap away into the distance again. And then an evening...... and....

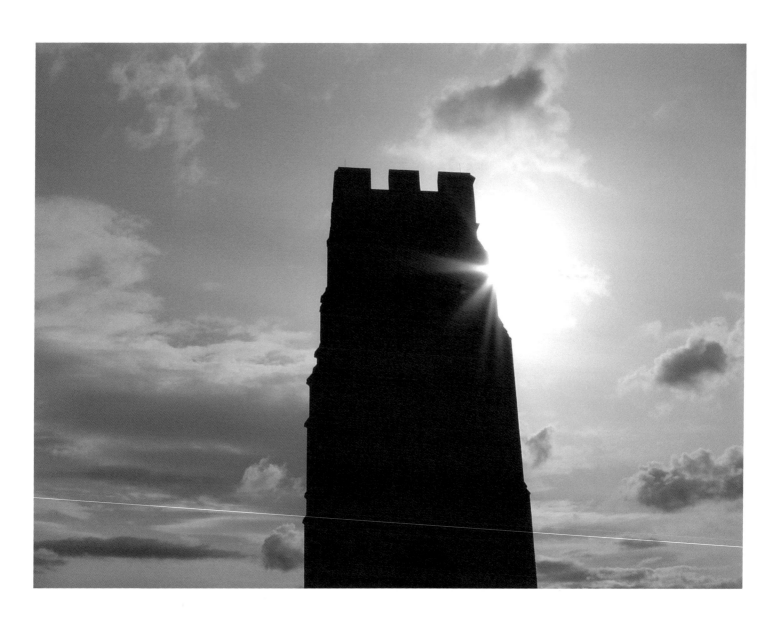

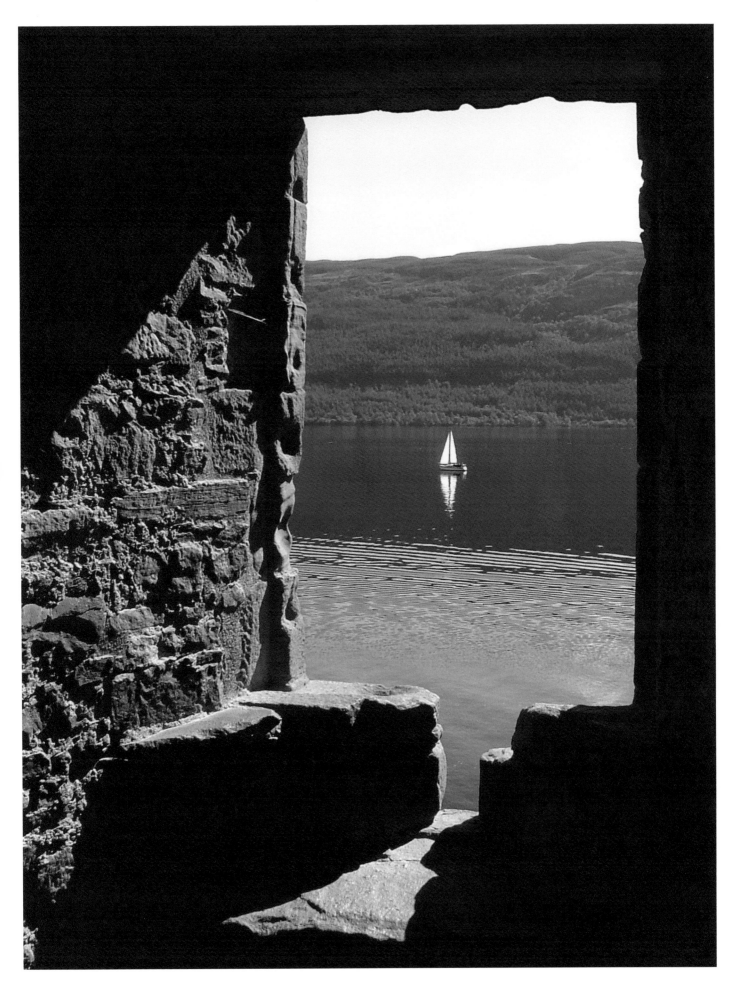

As I take my bounding two-stairs-at-a-time steps up behind her, I know.

I cannot speak of it, cannot think on this even. I simply know. And she who has been so much, so intriguing, has taken the role of the necessary link in the chain that has always been there........waiting.

A black door from the street. A slightly neglected hallway in a rather interesting mews house.

The sound of the gulls.

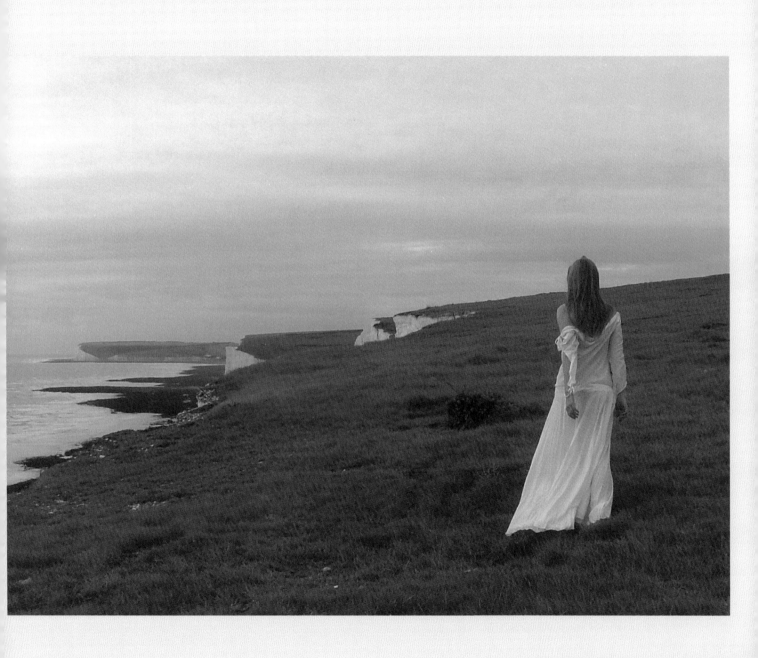

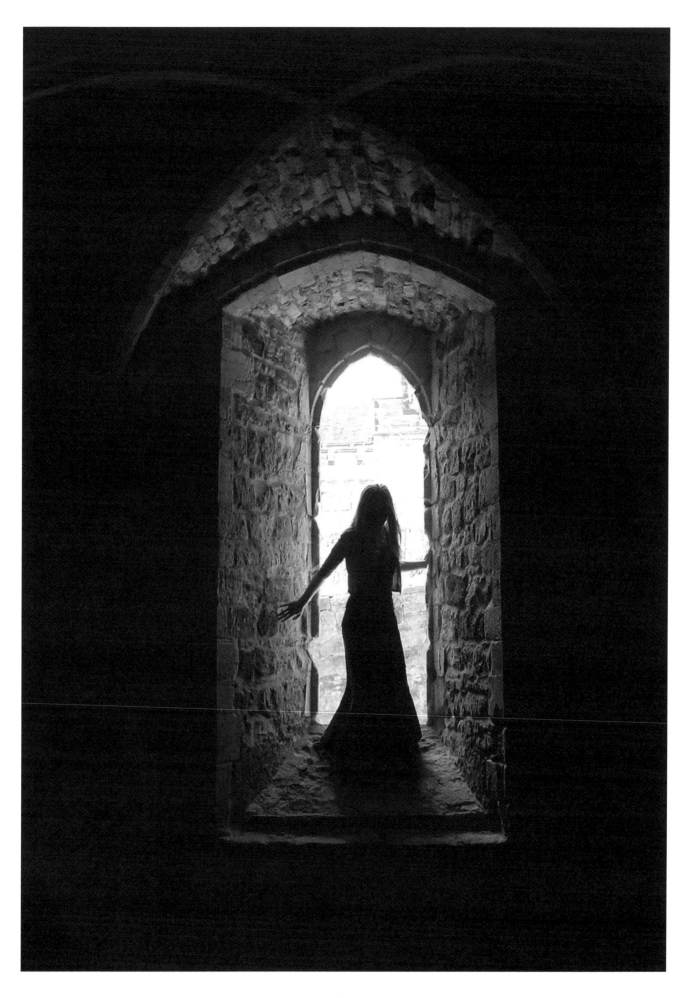

THIS BOOK is dedicated to the people that smiled at me in the street, the shop, or on the train. That offered something positive and inspiring and broke the mundanity of modern day life.

The images are diverse, some very simple, one or two being personal favourites that work on many different levels. I hope that by offering a selection of photographs, along with my thoughts, that I am able to provoke something that will return the compliment.

To my children and my childrens mother, my family, to the aquaintances that shared their precious time with me while I was "waiting". And now, almost prophetically, as I have almost inadvertently found myself.... This is for you.

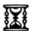

# Biography

STILL HAVING TO CONTEND with my lingering life crisis, although now without owning the sleek hulled powerboat Morgance, I am trying to think of how I would best describe myself.

'Rogue chromosome' always seems to raise an amused response or a sigh of agreement with such a truth. Those two words very accurately coined by the long suffering former partner and stoic mother of my three endearing and provocative children, each of them possibly having been brushed with some of my characteristics, much to their mothers annoyance.

I am the prodigal son of a south London bus conductor, born to devoted parents who met and married during the years of world war II. One of six children, my siblings all very distinctive 'Golding' individuals scattered around England pursuing very different lives.

And of them, I am the one to whom the inevitable question is 'Do you still work

for the same company?' and what country are you just back from / going to?

Main aim?

As always to provoke a response!!

Desires?

As usual, many and quite fantastical.

Sit back, pour yourself a glass of your favourite tipple and ponder my images.

Enjoy!!

## www.alangoldingphotography.com

74

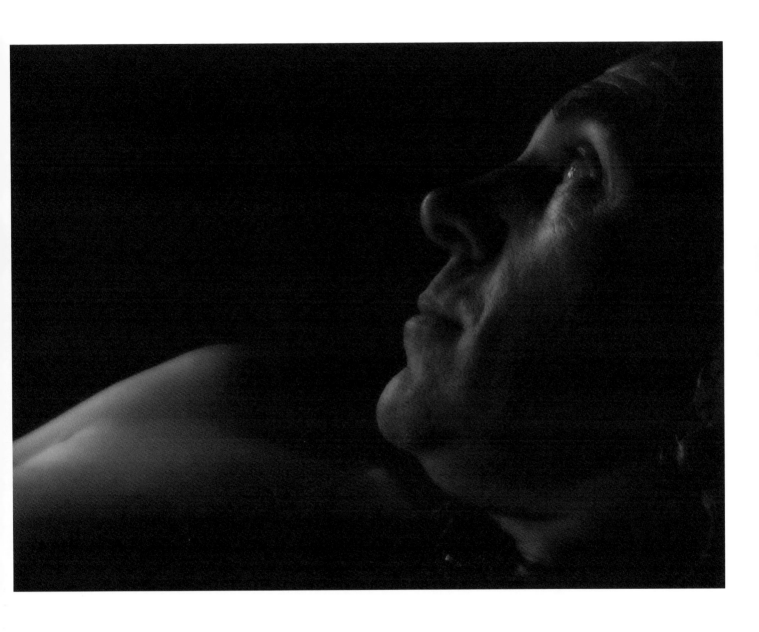

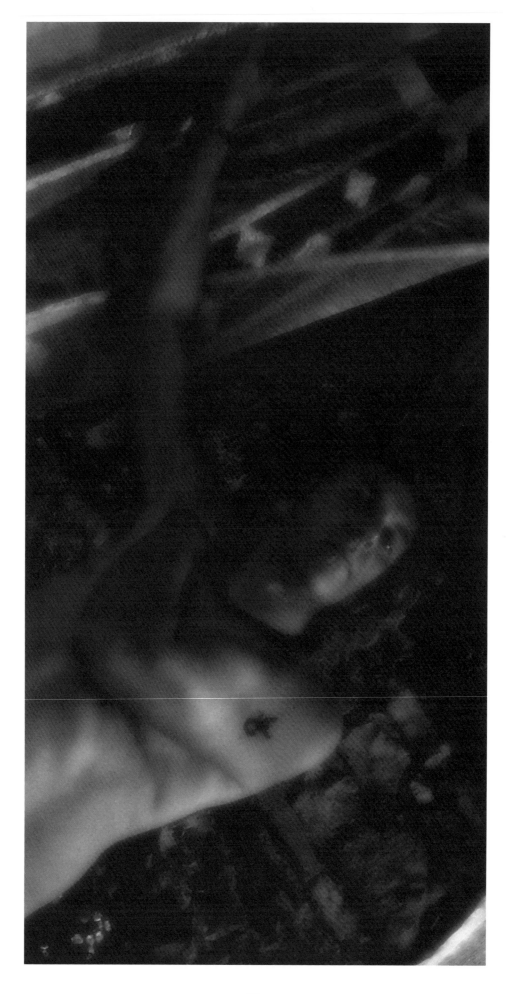

# Acknowledgements

Edited and proof read by Lucy Hunter.

Foreword by Lucy Hunter.

Models; Lucy, Jenna and M.

Additional photography; Alan in Brighton - Cover photo, Alan in kayak, Alan in Biography by Lucy Hunter.

For information regarding any of the locations or photographs please visit the website and enquire.

CPSIA information can be obtained
at www.ICGtesting.com
Printed in the USA
2480LVUK00007B